Psalms to Color
Words That Inspire
COLORING BOOK

Good Books books may be purchased in bulk at special discounts for sales promotion, corporate gifts, fund-raising, or educational purposes. Special editions can also be created to specifications. For details, contact the Special Sales Department, Good Books, 307 West 36th Street, 11th Floor, New York, NY 10018 or info@skyhorsepublishing.com.

Good Books is an imprint of Skyhorse Publishing, Inc.®, a Delaware corporation.

Visit our website at www.goodbooks.com.

10 9 8 7 6 5 4 3 2 1

Print ISBN: 978-1-68099-199-4

Cover and interior artwork by Ted Menten

PRAISE

Let everything that has breath
praise the LORD!

Praise the LORD!

Psalm 150:6

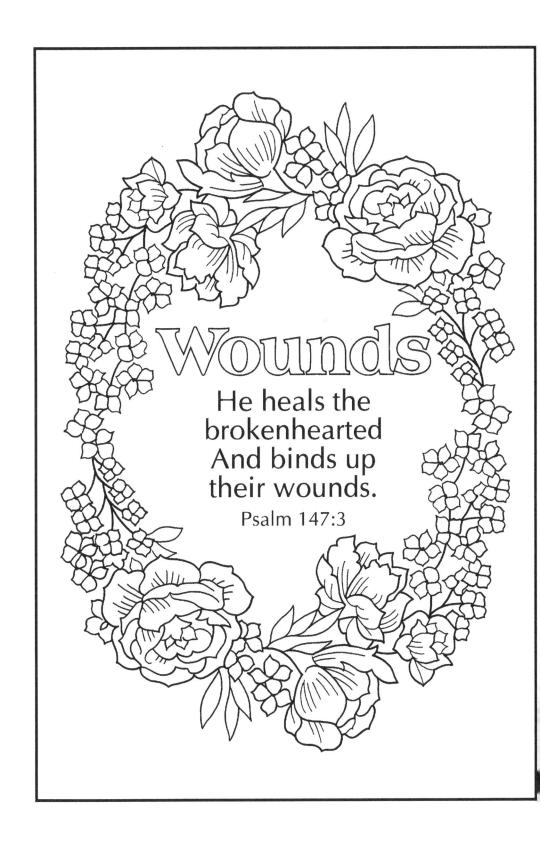

Wounds

He heals the
brokenhearted
And binds up
their wounds.

Psalm 147:3

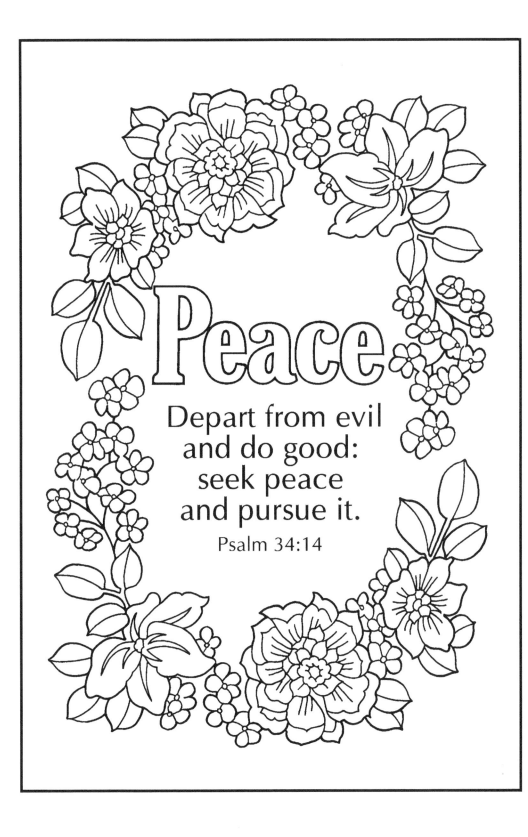

Peace

Depart from evil
and do good:
seek peace
and pursue it.

Psalm 34:14

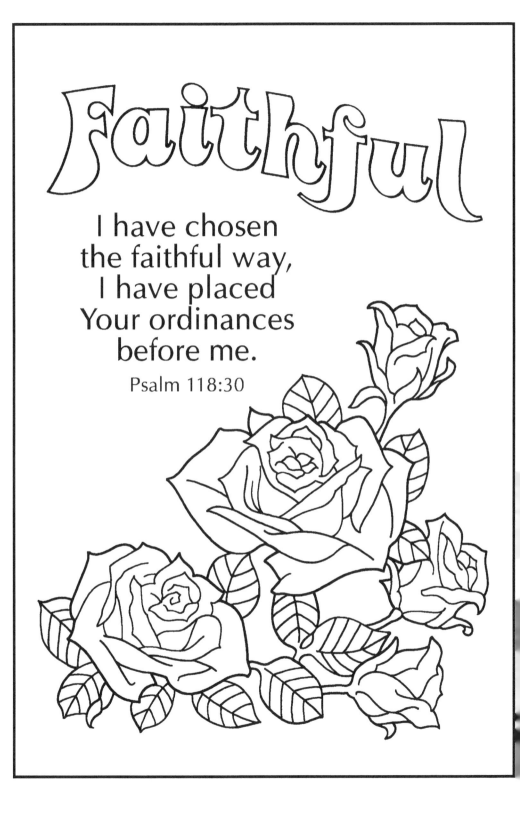

Faithful

I have chosen
the faithful way,
I have placed
Your ordinances
before me.

Psalm 118:30

PEACE

The LORD
will give strength
to His people;
The LORD will bless
His people
with peace.

Psalm 29:11

REJOICE

This is the day
which the LORD
has made.
Let us rejoice
and be glad in it.

Psalm 118:24

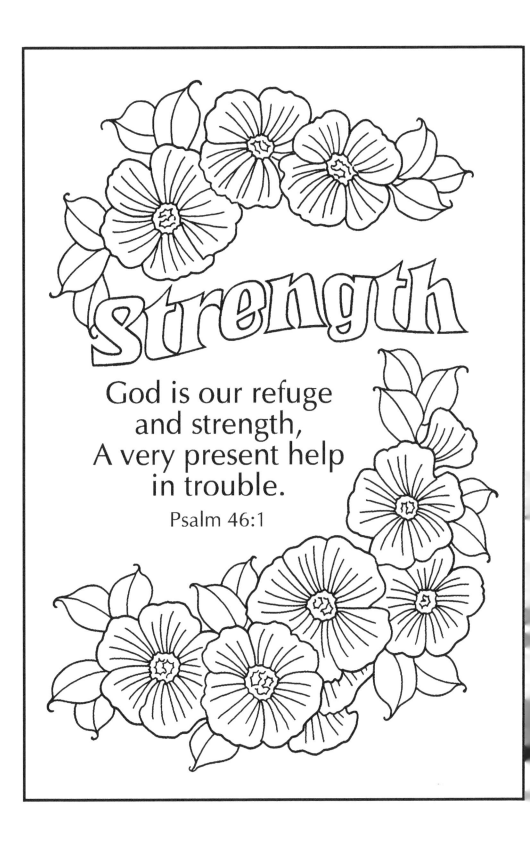

Strength

God is our refuge
and strength,
A very present help
in trouble.

Psalm 46:1

praise

He put
a new song
in my mouth,
a hymn of praise
to our God.

Psalm 40:3

Light

The LORD is my light
and my salvation,
Whom shall I fear?
The LORD is
the defense of my life;
Whom shall I dread?

Psalm 27:1

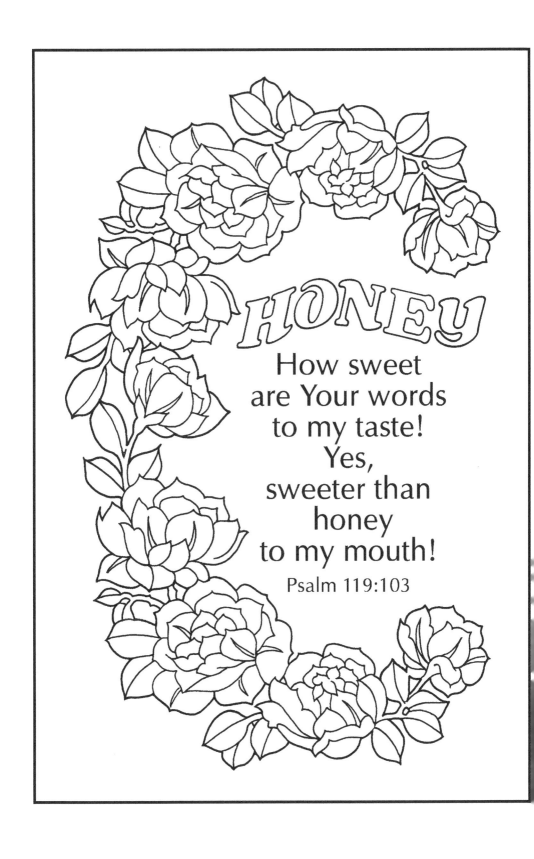

HONEY

How sweet
are Your words
to my taste!
Yes,
sweeter than
honey
to my mouth!
Psalm 119:103

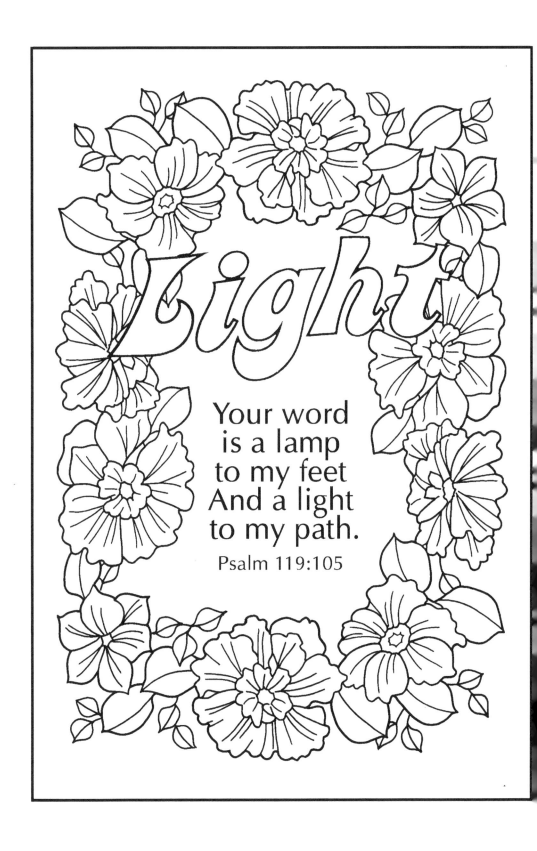

Light

Your word
is a lamp
to my feet
And a light
to my path.

Psalm 119:105

STRENGTH

The God
who girds me
with strength
And
makes my way
blameless?

Psalm 18:32

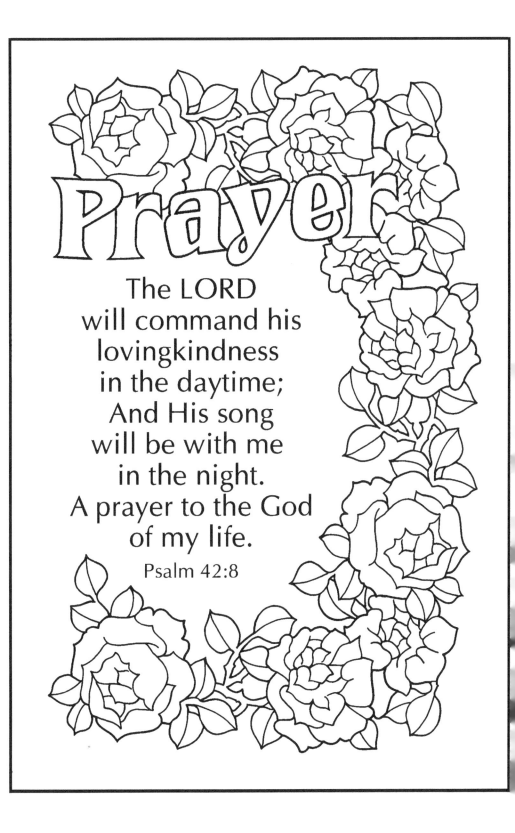

Prayer

The LORD
will command his
lovingkindness
in the daytime;
And His song
will be with me
in the night.
A prayer to the God
of my life.

Psalm 42:8

SHEPHERD

The LORD
is my shepherd,
I shall not want.
He makes me
lie down in
green pastures;
He leads me
beside
quiet waters.

Psalm 23:1

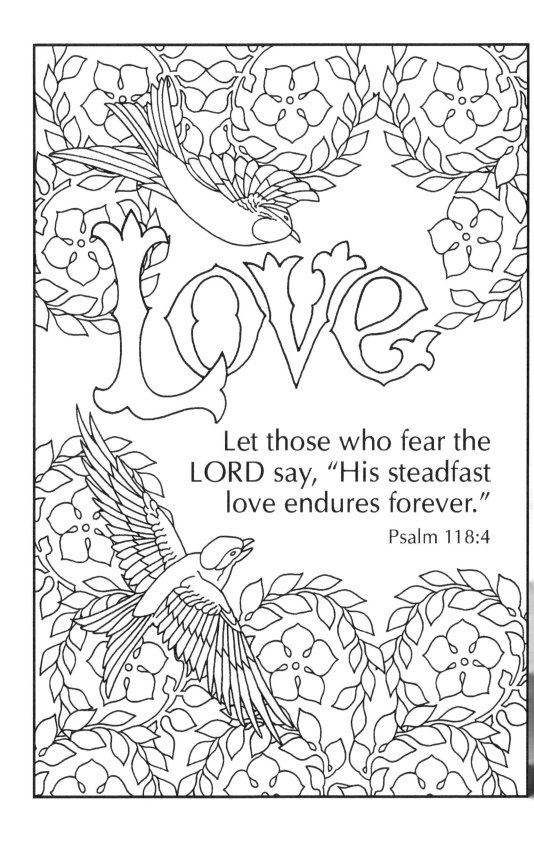

Let those who fear the LORD say, "His steadfast love endures forever."

Psalm 118:4

BLESSED

O LORD of hosts, How blessed is the man who trusts in You!

Psalm 84:12

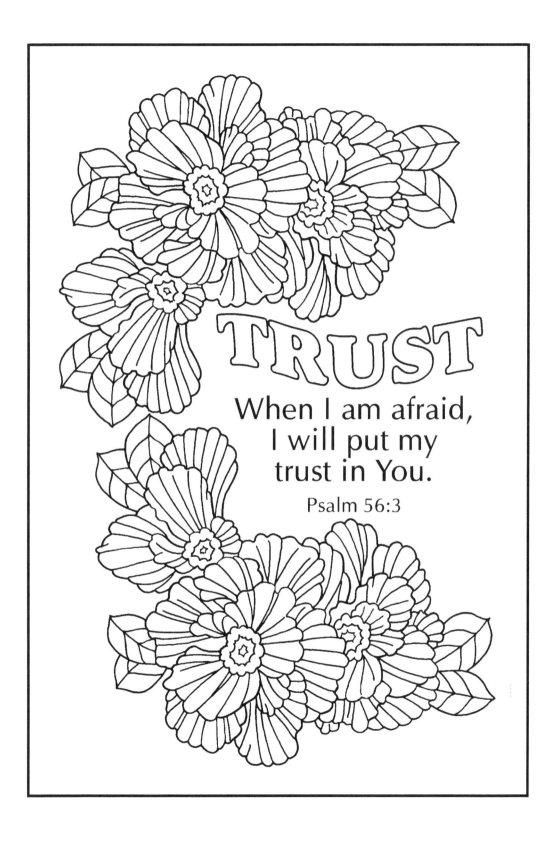

TRUST

When I am afraid,
I will put my
trust in You.

Psalm 56:3

PRAYER

The LORD will command
His lovingkindness
in the daytime; And
His song will be
with me in the
night. A prayer to
the God of my life.

Psalm 42:8

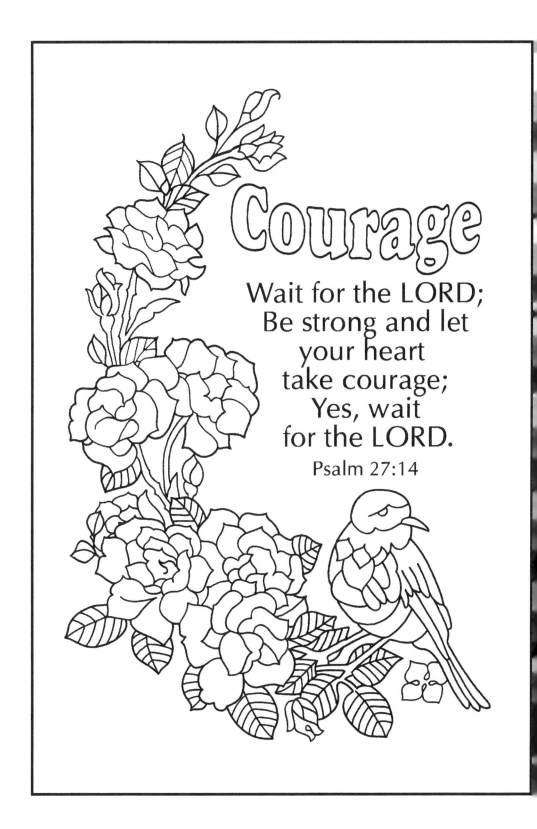

Courage

Wait for the LORD;
Be strong and let
your heart
take courage;
Yes, wait
for the LORD.

Psalm 27:14

MEDITATION

May the words of my mouth
and the meditations of my heart
be pleasing to you, O Lord,
my rock and my redeemer.

Psalm 19:14

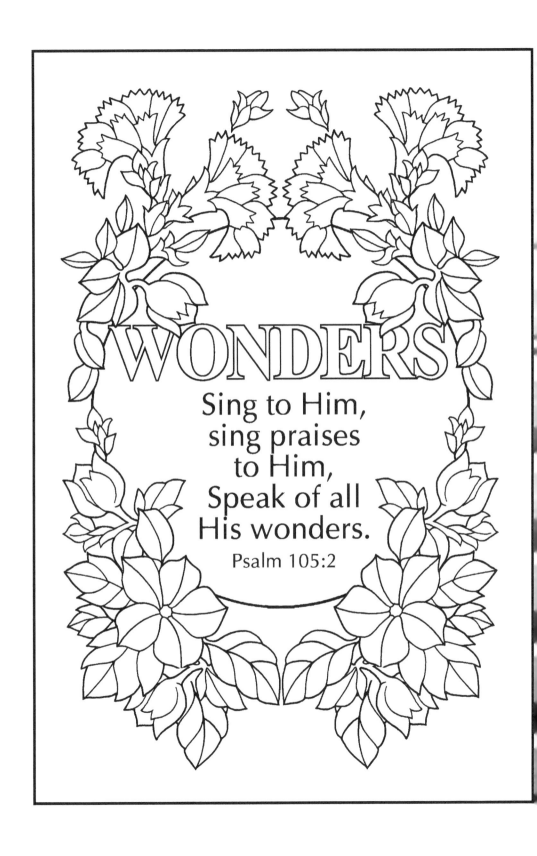

WONDERS

Sing to Him,
sing praises
to Him,
Speak of all
His wonders.

Psalm 105:2

TROUBLE

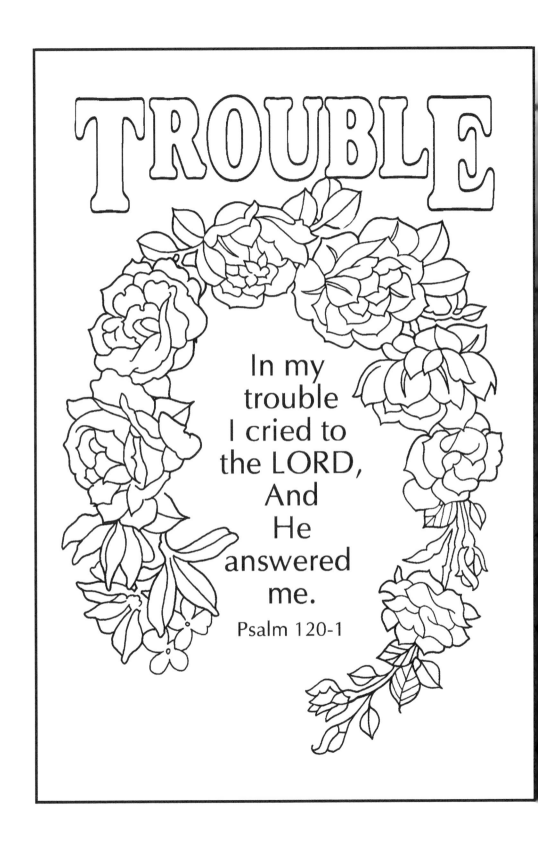

In my trouble I cried to the LORD, And He answered me.

Psalm 120-1

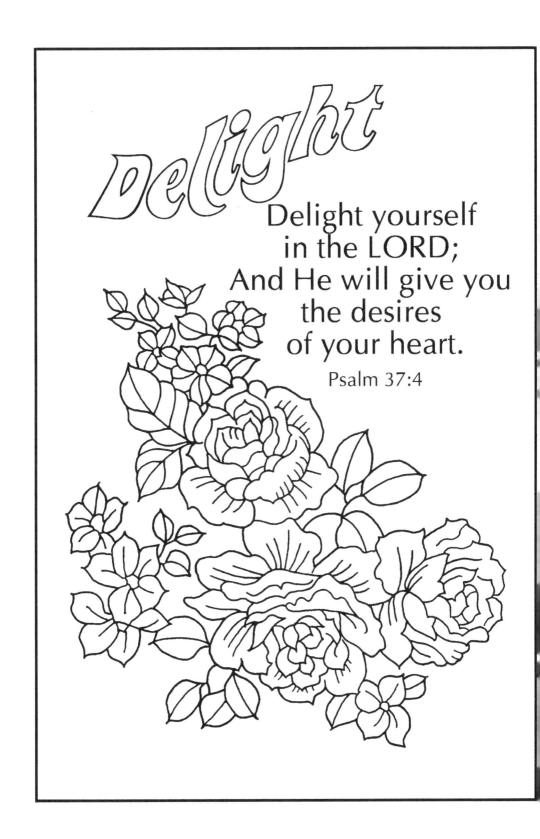

Delight

Delight yourself
in the LORD;
And He will give you
the desires
of your heart.

Psalm 37:4

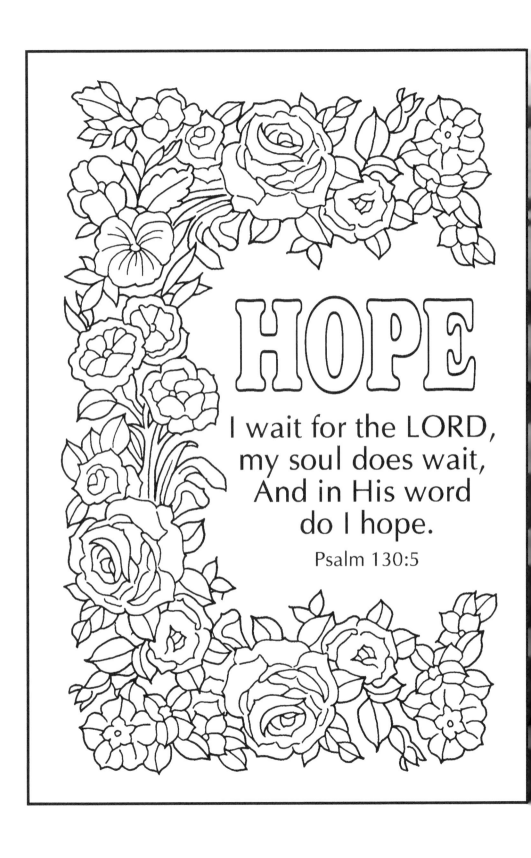

HOPE

I wait for the LORD,
my soul does wait,
And in His word
do I hope.

Psalm 130:5

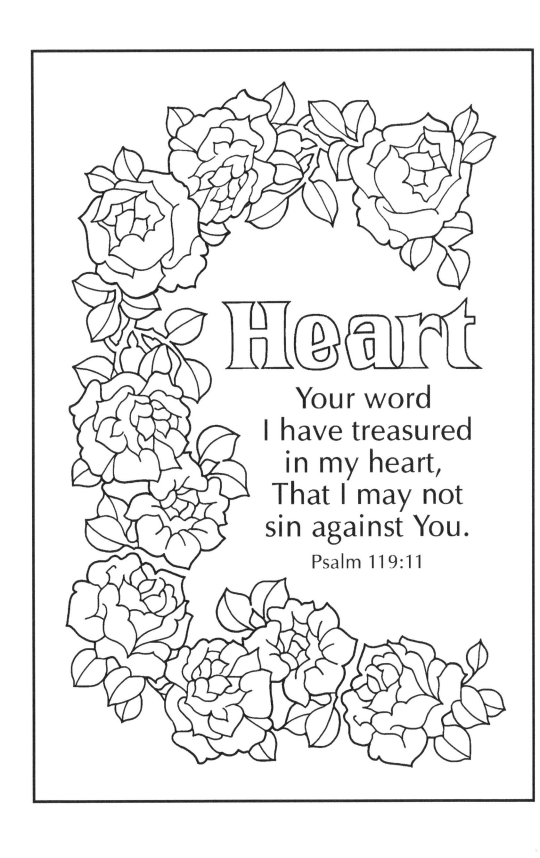

Heart

Your word
I have treasured
in my heart,
That I may not
sin against You.

Psalm 119:11

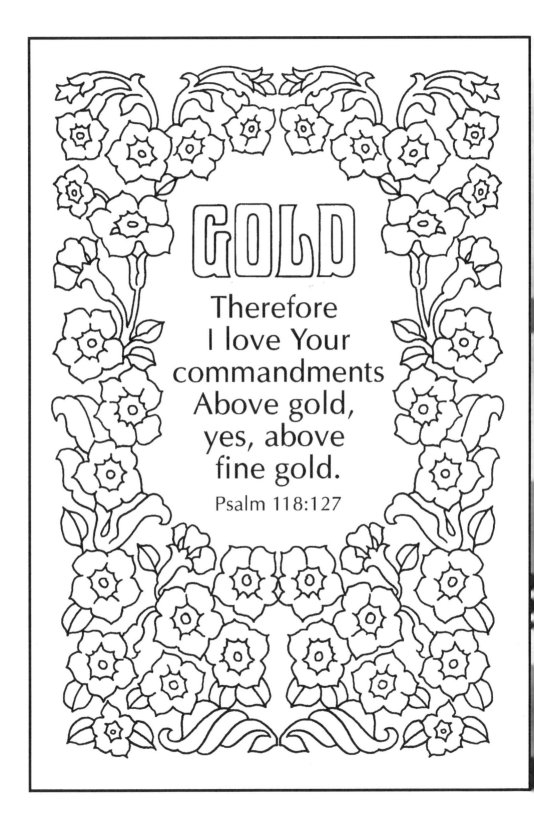

GOLD

Therefore
I love Your
commandments
Above gold,
yes, above
fine gold.

Psalm 118:127

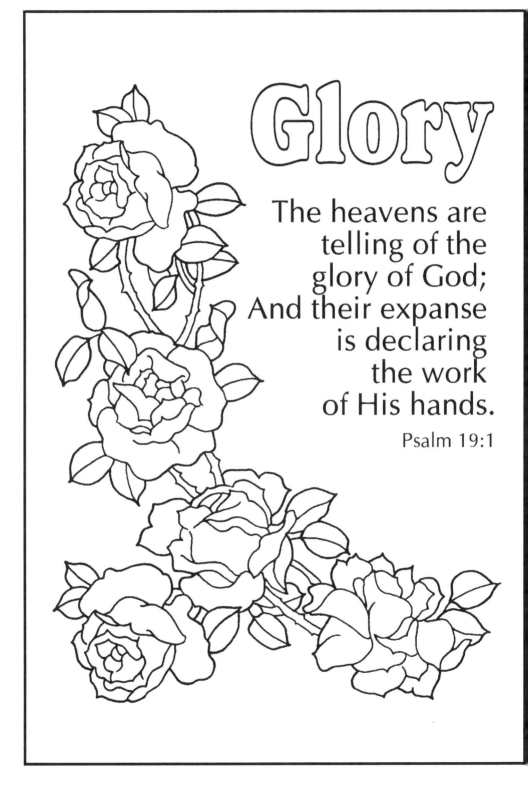

Glory

The heavens are telling of the glory of God; And their expanse is declaring the work of His hands.

Psalm 19:1

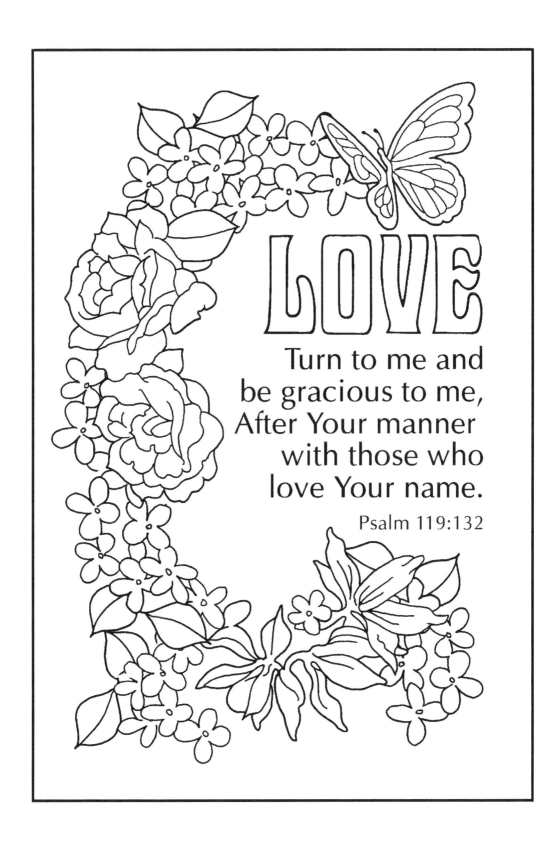

LOVE

Turn to me and
be gracious to me,
After Your manner
with those who
love Your name.

Psalm 119:132